EDGAR DEGAS

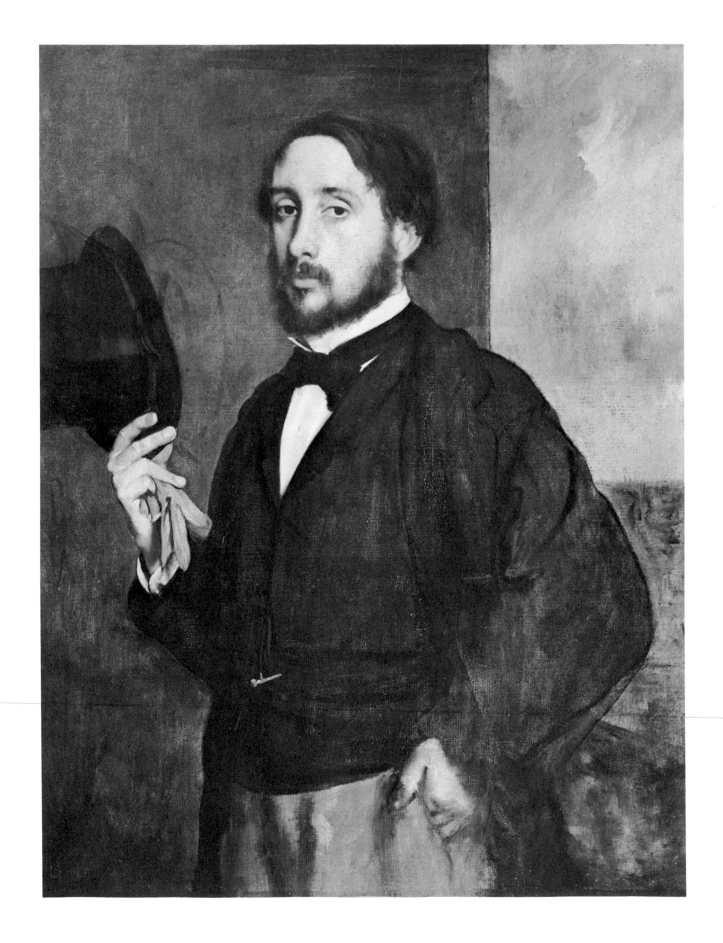

DEGAS

E. John Bullard

National Gallery of Art
Washington, D.C.

McGraw-HILL BOOK COMPANY · NEW YORK·LONDON·TORONTO·SYDNEY

Cover picture, *The Violinist* (c. 1879), charcoal with white on blue-gray paper, 16½″ x 11¾″, Museum of Fine Arts, Boston, William Francis Warden Fund.

EDGAR DEGAS was both a man and an artist of contradictions. Raised in a conservative, upper-middle-class environment, he decided quite early to become an artist, against the wishes of his family. Yet he always remained aloof from the bohemianism of the Paris art world, living a quiet, uneventful life. Known for his pictures of women—ballerinas, laundresses, milliners, bathers—he never married, never, as far as we know, had a love affair. Trained in the academic, neoclassic traditions of the École des Beaux-Arts, he realistically depicted scenes of Parisian life completely unacceptable to the art establishment of his time. Associated historically with the Impressionists, he never painted outdoors and rarely depicted landscape. One of the most accomplished draughtsmen of all time, his use of vibrant, expressive color became his primary concern in his late works. Considered today a traditionalist, the last of the great French classicists in the line of Poussin, David, and Ingres, Degas was one of the first to understand and creatively use the new pictorial possibilities offered by photography and Japanese prints. Altogether he was a complex, sensitive, and intelligent individual, completely dedicated to his art.

He was born Edgar Germain Hilaire de Gas on July 19, 1834, at 8 rue Saint-Georges in Paris, the first child of Auguste de Gas and Célestine Musson de Gas. The de Gas family was the epitome of the wealthy bourgeoisie then assuming power in France during the reign of Louis Philippe. Auguste managed the Paris branch of his family's bank, an institution founded in Naples by his father after his flight from France during the 1789 Revolution. Edgar's mother was from a prosperous New Orleans Creole family. Not only were the de Gas rich and respectable, they also had important aristocratic connections. Monsieur de Gas' three sisters had all married Neapolitan noblemen: the Duca di Sant'Angelo a Frosolone, the Duca di Montejasi, and Baron Bellelli, while Madame de Gas' oldest sister had married a Frenchman, the Duc de Rochefort.

Following the birth of their first son, Monsieur and Madame de Gas had four more children during the next ten years: Achille, Thérèse, Marguerite, and René. In 1845, the year his youngest brother was born, Edgar entered the Lycée Louis-le-Grand, a fashionable Paris boarding school, where he received an excellent classical education. Two years after he began his studies his mother died, leaving her husband to raise the five children.

Monsieur de Gas had a great enthusiasm for music and many well-known musicians frequented his home. A number of his wealthy friends had important art collections to

Frontispiece.
Self-Portrait (c. 1862)
oil, 36″ x 28⅜″
Calouste Gulbenkian Foundation
Lisbon

[Facing this page]
Detail of Slide 20

which he took his eldest son. This civilized and cultured atmosphere may have prompted Edgar to excel in his drawing class, the only subject in which he received first honors at graduation in 1853.

By that time Edgar was determined to become an artist, a desire which did not meet with the approval of his father who hoped that his eldest son would join the family bank. As a compromise, Edgar began the study of law at Faculté de Droit in 1853 and in the same year entered the studio of Félix Joseph Barrias, a mediocre academic painter.

At the time, the French art world was split into three opposing groups: the Neoclassicists, led by Ingres and his followers, who dominated the state-run École des Beaux-Arts and the official exhibitions at the Salon; the Romanticists—Delacroix and his followers; and the Realists—Courbet and his followers. It was to the Neoclassicists that Edgar Degas was first attracted. (The artist began spelling his name as one word early in his career.) He was already personally familiar with the work of Ingres, which he saw at the home of his school friend Paul Valpinçon. Possessing a natural facility for drawing, Degas was attracted to the style which emphasized the importance of line. The neoclassicist course of study, as taught at the École, consisted of drawing constantly, first from casts of antique sculpture, then later from the nude model. Copying works by the Old Masters, either from reproductions or from the originals, was considered essential. This was exactly the procedure Degas followed for over a decade.

The year he entered Barrias' studio he registered at the Louvre and at the Print Room of the Bibliothèque Nationale to copy works in their collections. A typical example of this practice (Figure 1) shows the informal combination of motifs from several sources which had attracted his attention. In 1854, after dropping out of law school, Degas moved to the studio of Louis Lamothe, a minor pupil of Ingres. A year later he enrolled at the École des Beaux-Arts, the citadel of neoclassicism where, however, he remained for only a short time. In that same year, through his friend Valpinçon's father, he visited Ingres, who advised him to "Draw lines, young man, many lines from memory or from nature; it is in that way that you will become a good artist."

Degas' most frequent subjects during this early period were members of his own family, of whom he did numerous drawings. With Ingres' advice and example firmly in mind, Degas drew his brother René standing at a desk (Figure 2). A comparison between this youthful work and a portrait drawing by Ingres (Figure 3) shows a similar use of line to define form, rather than modeling with tone, and a preciseness of detail. But Degas' work, although accomplished, betrays the stiffness and slight awkwardness typical of a pupil.

The dream of every student of the École was a trip to Italy to see and study the great works of antiquity and of the Renaissance. For Degas, as a result of his wealth and his Italian relations, such trips were numerous. Probably first in 1856 and then regularly for the rest of the decade, he journeyed through Italy, visiting relatives in Naples and Florence and copying works by the Italian masters, such as Raphael, Michelangelo, and Mantegna. In 1856 and 1857 he established himself in Rome, where he may have studied informally

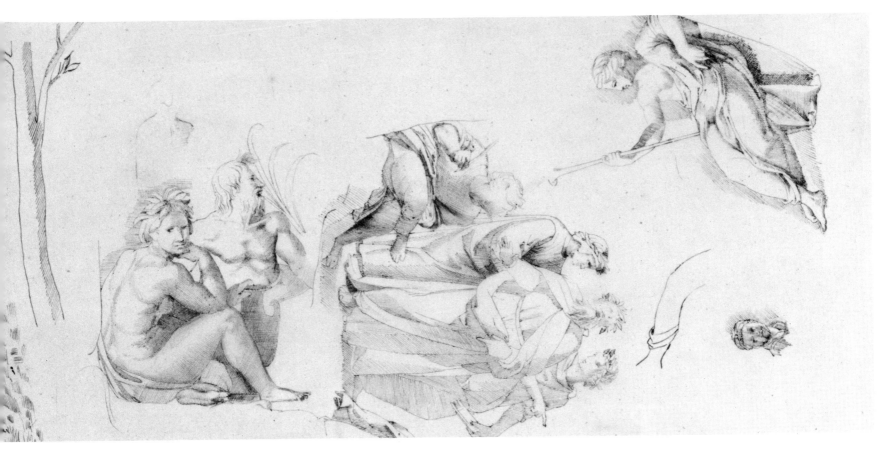

Figure 1.
Figures after Italian Renaissance Engravings (c. 1853-56)
pen and ink, 6″ x 12½″
Fogg Art Museum, Harvard University
Anonymous gift in memory of W. G. Russell Allen

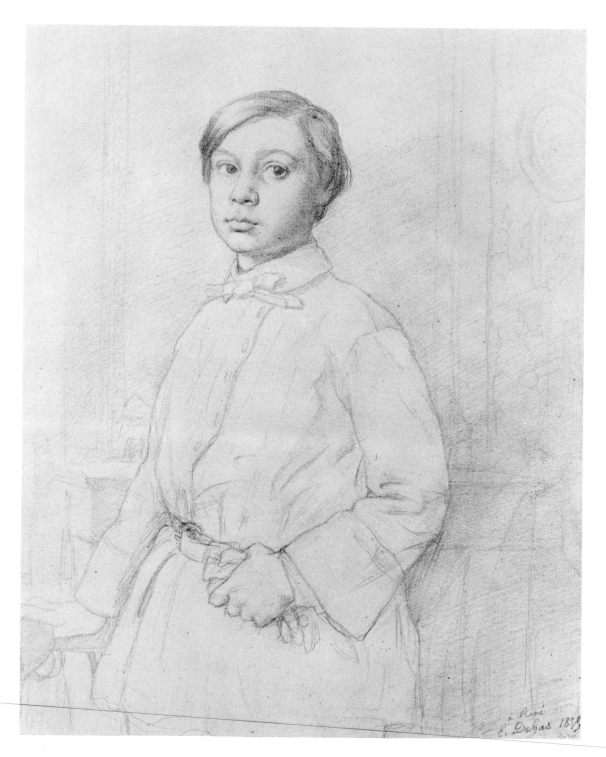

Figure 2.
René Degas (1855)
pencil, 11½″ x 9″
From the Collection of Mr. and Mrs. Paul Mellon

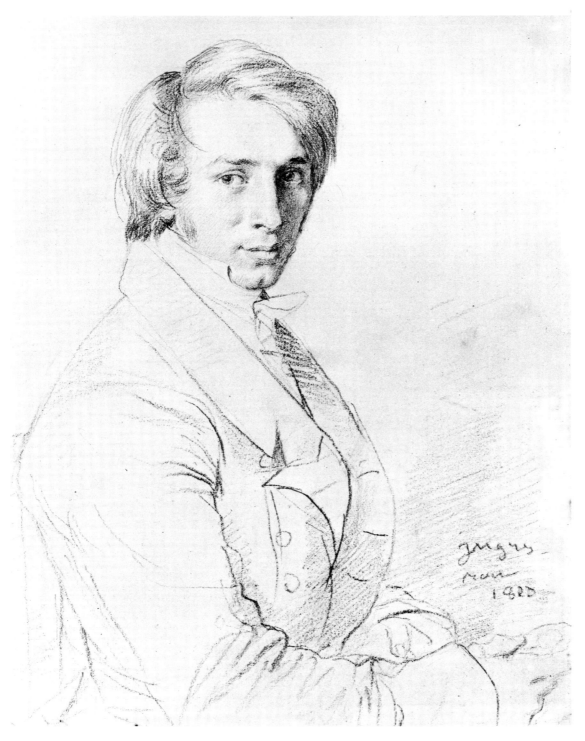

Figure 3.
J. A. D. Ingres (1780-1867)
Portrait of the Painter Ursin Auguste Vatinelle (1820)
pencil, 7³⁄₁₆″ x 5½″
The Metropolitan Museum of Art
Bequest of Grace Rainey Rogers, 1943

at the French Academy in the Villa Medici. In July 1858 he traveled by carriage from Rome to Florence, recording what he saw in such places as Assisi and Orvieto in his notebooks. In Florence he stayed with his uncle, Baron Bellelli. There he began the first of many studies for a large group portrait of the Bellelli family (Slide 1). This picture, his first important work, was completed the following year in Paris.

The years 1860 to 1870 were to be decisive for the formation of Degas' mature style. During this decade he met Édouard Manet and the young artists who would later be known as the Impressionists. He discovered Japanese prints and became interested in photography. And he executed the first of his many pictures of the racecourse and the theater.

The 1862 portrait of himself (Frontispiece) shows Edgar Degas as a young Parisian dandy, elegantly tipping his hat: the aristocratic, often haughty habitué of the best salons of the Second Empire. He was then, as later, a slim, short, seemingly fragile man, with a high domed forehead covered with silky chestnut hair, quick, questioning eyes, and a delicate mouth under a small mustache. By this date Degas already possessed a formidable wit which in later years was feared for its acid sarcasm, particularly by those holding contradictory opinions. He was a proud, intelligent, and slightly introverted man, who was determined from the beginning to devote his entire life to art. At twenty he wrote in a sketchbook: "I think that to be a serious artist today . . . one must be immersed in solitude." And later, he has often been quoted as saying: "A painter has no private life."

Beginning in 1859 Degas attempted several large, historical compositions in the manner of the academic successes of the day. He worked prodigiously on each of these paintings for extended periods, executing numerous studies of individual figures and groupings before starting on the actual picture. The last of these works, *The Evils Befalling the City of Orléans,* served as Degas' first Salon entry in 1865. He continued to show at the Salon until 1870. Subsequent entries included a number of portraits and his first large racecourse painting, *The Wounded Jockey.*

In the fall of 1861 Degas visited the country estate of his friend Paul Valpinçon, at Ménil-Hubert in Normandy. This part of France was important for horse breeding and here Degas was introduced to horse racing. An English sport, racing became the popular and fashionable pastime for the French upper class during the reigns of Louis Philippe and Napoleon III. The Jockey Club, the exclusive men's club, was founded in Paris in 1833, while Longchamp, the racecourse on the outskirts of the city, opened in 1857. What more natural subject for an artist of Degas' background than racing? He was partly inspired by contemporary English racing prints and, probably, by the earlier horse pictures of the Romantic artist Théodore Géricault. As was typical of Degas' working method, he immediately began to make many drawings in sketchbooks he carried to the track, recording his observations of the various movements and positions of horse and rider. A drawing of 1866 (Figure 4) is a beautiful example of one of these multiple studies which later, in the studio, would be used to compose his paintings.

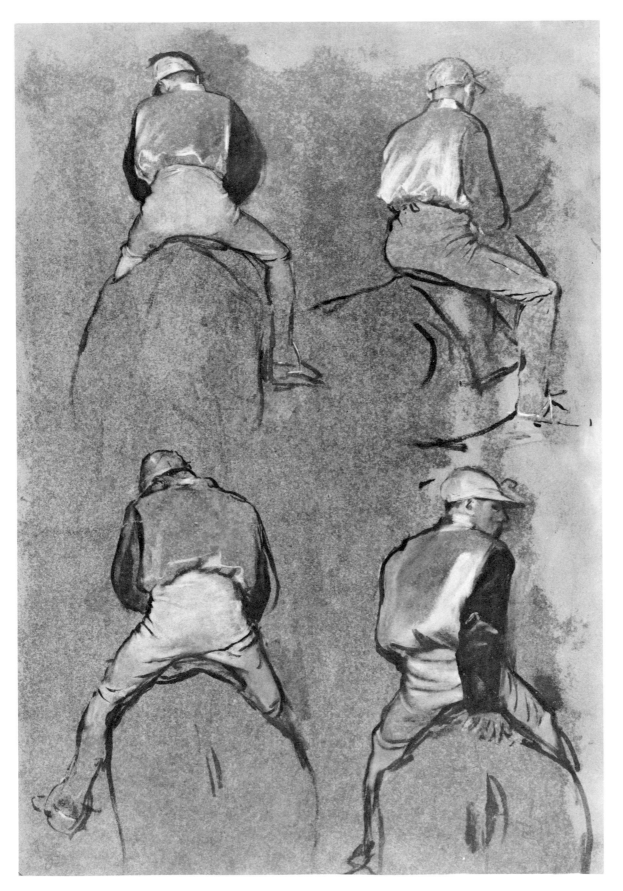

Figure 4.
Four Studies of a Jockey
(1866)
brush with oil
heightened with white
17¾″ x 12⅜″
The Art Institute of Chicago
Mr. and Mrs. L. L. Coburn
Memorial Collection

Degas' interest in the racecourse was shared by another artist, Édouard Manet, whom he met about this time. Both were registered as copyists at the Louvre in 1861 and 1862 and this was presumably where they met. Both came from prosperous, bourgeois families and, sharing similar interests, were naturally attracted to one another. Manet (Figure 5), the leader of the younger Realists, achieved a notorious reputation in France after the exhibition of *Le déjeuner sur l'herbe* at the Salon des Refusés in 1863, and *Olympia* at the official Salon two years later. The first showed two couples picnicking in the country, the ladies unashamedly nude, the men fully dressed. The second was a portrait of a reclining nude courtesan awaiting her lover. Both paintings were completely unacceptable to bourgeois, Victorian morality. Manet encouraged Degas to abandon the academic, historical compositions on which he was then working and to concentrate on depicting scenes of contemporary life, such as the racecourse.

In the late sixties, through Manet, Degas began to meet the young painters who gathered regularly at the Café Guerbois, such as Monet, Renoir, Pissarro, and Fantin-Latour, as well as the Naturalist writers Edmond Duranty and Émile Zola. These men, later to be grouped together as the Impressionists, composed the avant-garde of the Parisian art world and, as such, were battling the academic art establishment for recognition.

Of the new ideas exchanged by these young artists, Degas was particularly interested in the vogue for Japanese prints. Félix Bracquemond's chance discovery in 1856 of an edition of Hokusai's *Manga,* a printed woodblock sketchbook of figures and scenes of daily life, marked the beginning of the Japanese vogue. Bracquemond excitedly shared his discovery with his artist friends, including Degas. In 1862, a shop specializing in oriental merchandise, La Porte Chinoise, opened in Paris where artists could buy porcelains, costumes, and Japanese woodblock prints. These items began to appear as accessories in the paintings of the Café Guerbois artists during the 1860s.

The more important result of this vogue was the stylistic lessons learned by French artists from the study of the Japanese prints. Degas, who began collecting these woodcuts quite early, probably gained the most benefit from such study. These prints, called *ukiyo-e* (literally "pictures of the floating world"), depicted a great variety of scenes from everyday life: different household activities, people traveling, musicians and dancers performing, courtesans entertaining their guests, and actors applying their make-up. These prints must have suggested fresh possibilities to Degas, then searching for an alternative to sterile, academic subjects. Japanese prints are marked by a great pictorial simplicity. By using a number of stylistic conventions found in these works, Degas was able to achieve a similar effect in his pictures.

Some of the important lessons Degas derived from the Japanese were the asymmetrical arrangement of a composition; the subtle and decorative use of line; the depiction of a subject from an angle or viewed from above, often tilting the floor upward as a consequence; the use of flat areas of color and pattern; and the suppression of deep perspective. These elements can be seen in both Degas' etching *At the Louvre* (Figure 6) and Harunobu's

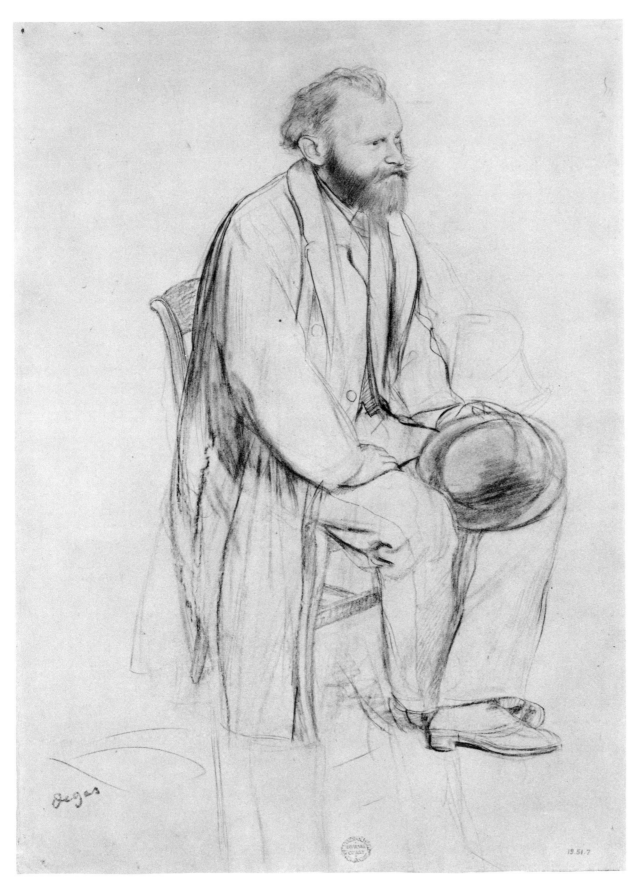

Figure 5.
*Study for a Portrait
of Edouard Manet*
(c. 1865)
black chalk and estampe,
13″ x 9⅛″
The Metropolitan Museum of Art,
Rogers Fund, 1918

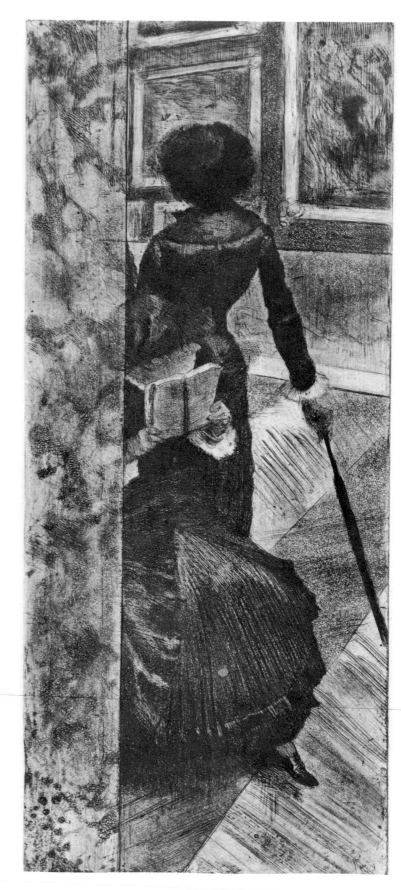

Figure 6.
Mary Cassatt at the Louvre (c. 1876)
etching and aquatint
National Gallery of Art, Washington, D. C.
Rosenwald Collection

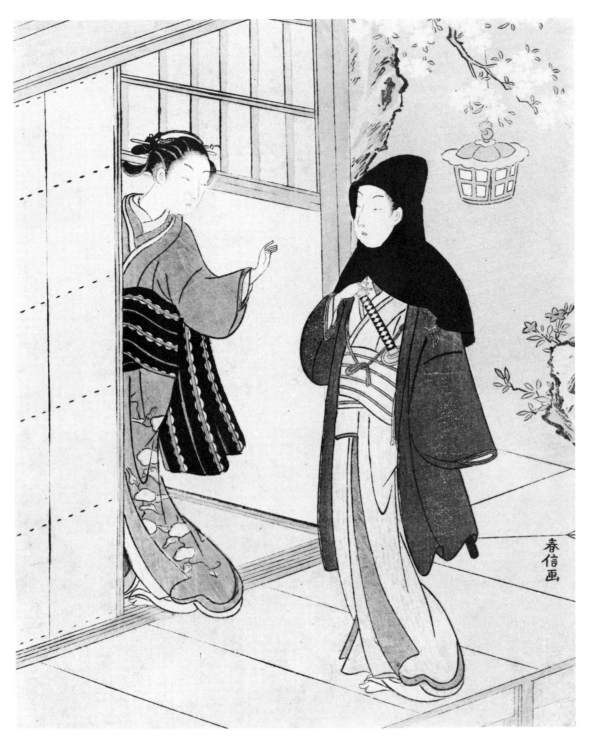

Figure 7.
Suzuki Harunobu (1725-1770)
At the Door
color woodcut, 10⅞" x 8⅜"
Philadelphia Museum of Art
Gift of Mr. and Mrs. Lessing J. Rosenwald
Photograph by A. J. Wyatt

At the Door (Figure 7), particularly the dramatic tilting of the floor, emphasized by the pattern of diagonal lines, and the use of a wall to casually cut off a figure. In many portraits of family and friends that Degas painted during the 1860s, these techniques were used to achieve freshness and spontaneity.

At the same time that Degas was discovering *ukiyo-e,* he was also exploring the similar pictorial conventions offered by photography. Photography was considered by then a legitimate aid to the portrait painter, and the daguerreotype was used extensively for this purpose. In 1858, instantaneous photography, the "snapshot," was made possible by faster exposures, and such photographs of Paris street scenes were widely available during the early sixties, which Degas surely saw. The casual, even awkward pose of a figure, an asymmetrical composition, the arbitrary cutting of objects by the frame, and an exaggerated perspective which makes foreground objects appear disproportionately larger than normal, are characteristics of these early instantaneous photographs. To most of his contemporaries these appeared to be strange distortions, but Degas realized their value in achieving more natural and realistic compositions and incorporated them into his pictures. As his interest in photography grew, he collected photographs of his favorite subjects, such as dancers, and later took them himself.

The natural outcome of a typically Parisian love of the theater, and Degas' and his father's passion for music, and their numerous friendships with musicians, was for the artist to paint these subjects. His first attempts in this direction, depictions of scenes from the operas *Semiramis* (1860–61) and *La Source* (1866–68), were done in the academic manner of his other historical compositions of the period. His first important works in this line were various portraits of musicians, particularly *The Orchestra of the Paris Opera* (Figure 8) of 1868–69, which depicts, among others, his friend, the bassoonist Désiré Dihau. This extraordinary example of collective portraiture, with the dancers at the footlights cut in half by the top edge of the painting, is typical of Degas' first theater pictures in that he depicted the scene from the viewpoint of the audience.

In July 1870, following the declaration of war between France and Germany, Degas' artistic career came to a temporary halt. After the fall of the Second Empire and the establishment of the Third Republic, Degas volunteered for military duty and was assigned to an artillery unit of the Garde Nationale commanded by an old school friend, Henrí Rouart. The unfortunate result of this service was a severe cold which affected his already weak vision, particularly in the right eye—an affliction which would progressively worsen with time. Following the Armistice, Degas recuperated at the Valpinçons' Normandy estate, escaping the privations and dangers of the Paris Commune, the three-month socialist, anarchist insurrection of the spring of 1871, which was finally suppressed by loyal government troops.

Back in Paris, Degas returned with greater enthusiasm to his new subjects: the racecourse and the theater. Through friends he gained admittance to the classes and rehearsal rooms of the Paris Opera. Here he sketched the young dancers (ballet was an integral part of

Figure 8.
The Orchestra of the Paris Opera
(1868-69)
oil, 20⅞″ x 13¾″
Louvre, Paris

16

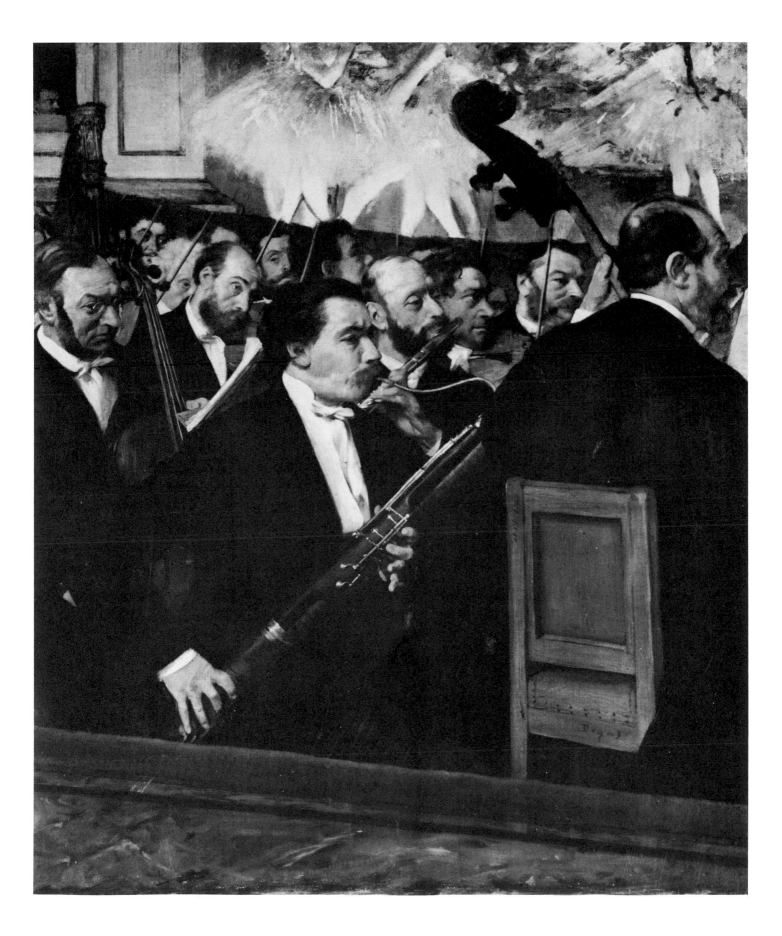

operatic productions) practicing at the bar, exercising, and resting (Figure 9). Degas was not interested in the pretty, glamorous aspects of the theater, rather he wanted to capture the characteristic movements and poses and the essential gestures of the dancers with the same detached and penetrating observation applied to his studies of horses and riders. As he later wrote to his friend, the sculptor Bartholomé: "... it is essential to do the same subject over again, ten times, a hundred times. Nothing in art must seem to be chance, not even movement."

In late October 1872, Degas left Paris for America to visit his two brothers in New Orleans. He traveled by ship to New York and then south by train. René and Achille de Gas had established a wine-importing firm in New Orleans six years earlier with a loan from the family bank. Degas, with typical bourgeois family pride, was pleased with his brothers' success and envied René his marriage to his cousin Estelle Musson, and their young children. Since the bright sun bothered his weak eyes, Degas worked indoors, attempting several family portraits. These, he wrote a friend, were difficult since "they have to be done more or less to suit the family taste, by impossible lighting, very much disturbed, with models full of affection but ... taking you far less seriously because you are their nephew or their cousin." Probably due to these distractions, few finished works resulted from the trip, with the exception of *The Cotton Office* (Slide 6), a unique combination of genre and group portraiture.

Degas was fascinated by America and the Creole life of New Orleans. "I like nothing better than the negresses of all shades, holding in their arms little white babies, so white, against white houses with columns of fluted wood and in gardens of orange trees," he wrote. But frustrated by his inability to adequately depict this world without long study, Degas was glad to depart for home in early March 1873. For, as he revealed to a friend: "Everything is beautiful in this world But one Paris laundry girl, with bare arms, is worth it all for such a pronounced Parisian as I am."

If the 1860s were Degas' formative years, the seventies were his most creative, the period of his most incisive and psychologically penetrating portraits (Figure 10) and finest dance pictures. It was also a decade of unhappiness in his personal life.

In 1874 Degas was forty. In February his father died in Naples, leaving the family firm on the verge of bankruptcy, in part due to the financial depression which followed the Franco-Prussian War. In order to settle the bank's monetary obligations and save the family honor, the firm was liquidated and Edgar, Achille, and their sister Marguerite Fèvre personally assumed all debts, which were paid in installments over a number of years. To raise money, Degas sold part of his personal art collection and, for the first time, was dependent on the sale of his work for his income. He was disappointed by the behavior of his brother René, whose large debt to the family bank was one cause of its insolvency. Refusing to assist his brothers, René abandoned his wife and children in New Orleans, remarrying a year later and returning to France. Deeply hurt by his brother's actions, Degas refused to see him and they remained estranged for twenty years.

Figure 9.
Young Ballerina Resting (c. 1880-82)
charcoal on cream paper, 9¹³⁄₁₆″ x 11½″
The Minneapolis Institute of Arts
Gift of Julius Boehler

Figure 10.
Reflection (La Mélancolie) (c. 1874)
oil on canvas, 7½″ x 9⅝″
The Phillips Collection, Washington, D. C.

For a number of years the Café Guerbois artists had discussed the possibility of holding their own group exhibition, in opposition to the Salon whose academic jury consistently rejected most of their work and opposed their innovative styles. While they had been able to sell some pictures to the young dealer Paul Durand-Ruel, they felt that a large exhibition would bring them wider public attention and, hopefully, critical acceptance. In December 1873 these painters, among them Degas, Monet, Renoir, Sisley, and Pissarro, formed a company to sponsor such an exhibition. Appropriate space was found in the vacated studio of the photographer Nadar in the center of Paris. Degas was enthusiastically active in the organization of the exhibition and persuaded a number of his friends to join the group, which called itself *Société anonyme des artistes, peintres, sculpteurs, graveurs, etc.* The exhibition opened on April 15, 1874, and featured 165 works by thirty artists. Degas exhibited ten paintings, drawings, and pastels depicting dancers, laundresses, and the racecourse. The one-month exhibition was only a success in its attendance, for the public came to jeer, laugh, and be outraged, reflecting the harsh reviews of the Paris critics. The most devastating review was in the comic weekly *Charivari,* written by Louis Leroy, who derisively labeled the artists Impressionists, a name derived from the title of a Monet entry, *Impression, Sunrise.*

The Impressionists (for that was now their unavoidable designation) were depressed and discouraged by this critical and popular rejection of their work. There were only a few perceptive collectors who bought paintings, at low prices. In 1876 the group held its second exhibition, this time reduced to eighteen participants, at Durand-Ruel's gallery. Degas showed twenty-four works, of which one reviewer wrote: "Try indeed to make M. Degas see reason; tell him that in art there are certain qualities called drawing, color, execution, control, and he will laugh in your face and treat you as a reactionary." There were six more Impressionist exhibitions during the next ten years, of which Degas participated in all but the one in 1882.

Although historically he has been grouped with these painters, it has been argued convincingly that Edgar Degas was not an Impressionist. Certainly his work is not similar in style or subject to that of Monet, Pissarro, or Sisley. These artists were mainly interested in painting landscape, directly from nature *en plein air.* Their primary concern was to record the changing effects of light and they used a high-keyed palette and broken brushwork to achieve this goal. Degas, on the other hand, always painted in his studio, basing his pictures on numerous sketches done from life. He disapproved of a passive fidelity to nature, remarking: "It is very well to copy what one sees, it's much better to draw what one has retained in one's memory. One reproduces only that which is striking; that is to say, the necessary. Thus, one's recollections and inventions are liberated from the tyranny which nature exerts." Degas rarely painted landscape. The few that he did, mainly in 1869 and in 1890, were generalized views executed from memory or based on photographs. He was a figure painter, interested in the line, form, and movement of the human body. Although he exhibited with the Impressionists and was deeply committed to their fight against the artistic estab-

lishment, Degas did not, it seems, consider himself an Impressionist (a term he despised). Regarding his Impressionist friends, he sarcastically said: "Do you know what I think of those painters who work on the roads? If I were the government I'd send a brigade of gendarmes to keep an eye on people who make landscape from nature!"

Degas only began to work seriously in pastel after 1875, although he first used it in the late sixties. Pastel became his favorite medium, as it ideally combined the elements of both drawing and painting. The sticks of colored chalk are used to create a composition of line, but the chalk, as it builds up on the surface of the paper, acquires mass and lines disappear in areas of solid color. In pastel, Degas could work more quickly than in oil, since he could keep on working and reworking a picture without waiting for it to dry. This was an important factor in the mid-seventies after the liquidation of his family's bank. He could produce pastels more quickly than oil paintings. Degas and his dealer Durand-Ruel also felt that by achieving new effects in the little-used pastel medium, special interest in his work would be created among collectors. In later years, as his blindness increased, he found pastels less of a strain on his eyes, since he did not have to set up a palette and mix colors.

Degas expanded the possibilities of the pastel medium by developing special methods to achieve a greater variety of effects. He sometimes combined pastel with oil or gouache in the same picture. By spraying boiling water on part of a pastel, he produced a wash which he could then work with a brush. Certain areas, such as a dancer's face, he would rub with his finger, blending the chalks together. To enable him to constantly rework his compositions, Degas used the best possible pastel fixative, an almost invisible adhesive which binds the chalk to the surface when sprayed on the picture. By fixing each layer of color, he could work over the same area again and again without disturbing the layers below, in this way achieving rich effects of one color showing through the next layer above.

While continuing to depict dancers and the racecourse, Degas turned to other subjects in the 1880s: laundresses, milliners, and women at their toilette. These new themes were more intimate and closer to everyday life than the restricted and artificial world of the theater.

Earlier in the century laundresses were a subject which appealed to Honoré Daumier, whose depictions of women lugging their baskets of wash through the streets show a distinct social consciousness. Degas was rather interested in the tedious routine of women ironing. These pictures, like his dancers practicing, are studies of exaggerated movements—women in archetypal positions of strain and exhaustion.

Degas' depictions of millinery shops grew out of his great interest in women's fashions. He delighted in the elaborateness of the female costume, with its bright colors, varied patterns, and rich materials. He often accompanied his lady friends to dressmakers and milliners, where he carefully observed the salesgirls attending to their customers and handling the merchandise.

The most important subjects for Degas after 1880 were nude women casually engaged in various stages of their toilette. Degas objectively described these works in the 1886 Impres-

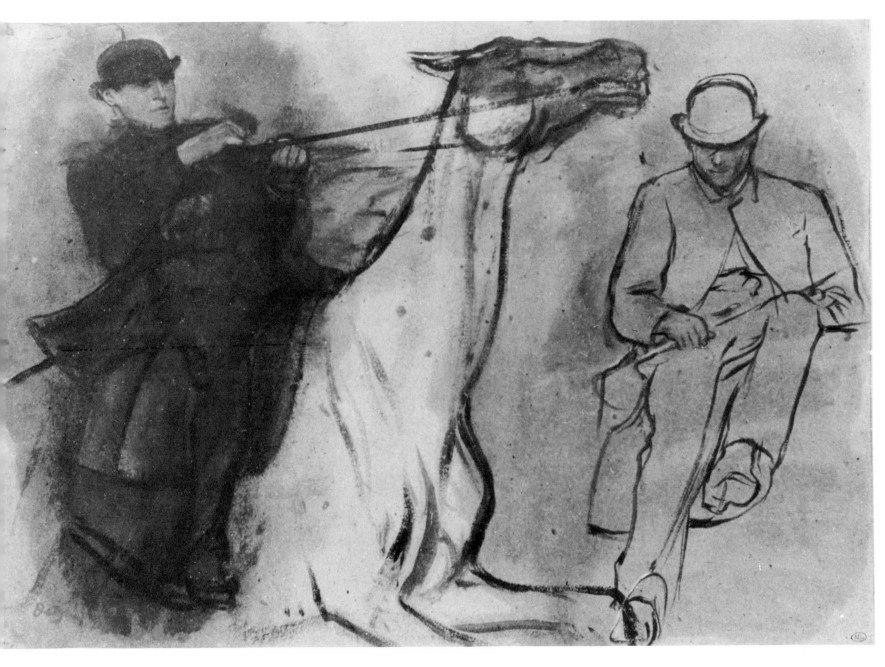

Figure 11.
Two Studies of a Groom (1875-77)
brown essence, heightened with gouache
9⅞″ x 13½″
Cabinet des Dessins, Louvre, Paris

sionist exhibition catalogue as "women bathing, washing, drying themselves, rubbing down, combing their hair or having it combed." He deliberately avoided stereotyped, classical poses. Eschewing all sentimentality and prettiness, he sought the natural, spontaneous appearance of an unobserved person, as if the subject was being viewed through a keyhole. There are innumerable drawings (Figure 12) and finished pictures of these women revealing the strains and tensions of bent bodies and twisted muscles as they performed their intimate routines. Degas actually had a tub brought into his studio where his models bathed naturally, never assuming a fixed pose. None of these pictures represented women as sensual, beautiful, or graceful. To the artist's Victorian contemporaries they appeared awkward and vulgar, if not obscene. Such pictures prompted the novelist J. K. Huysmans to accuse Degas of "throwing the most excessive outrage in the face of his century, dethroning that carefully cherished idol, woman, when he shows her debased, in her tub, in the humiliating postures of intimate care." Certainly Degas brought the same clinical detachment and acute observation to this subject as he did to his studies of horses and dancers. The faces of these women are usually turned away from the viewer or undelineated so that attention is concentrated on the movement and gesture of the body.

In his late works, particularly after 1895, Degas achieved a new richness of color. His eyesight continued to deteriorate, making it impossible for him to concentrate on the exact delineation of forms. The isolation of his near-blindness and a self-imposed seclusion forced him to turn inward, resulting in strongly expressionistic works. While he continued to depict the same subjects, the forms are distorted and figures assume angular, jutting poses. The pastel, now his exclusive medium, is laid down in broad, slashing strokes, layer upon layer. The backgrounds are no longer defined but become a mass of abstract line. His figures have a heaviness and sculptural weight, losing all sense of individual character. Everything is conceived in terms of pure color—bright oranges, vivid pinks and reds, harsh greens—creating a totally rich, jewel-like brilliance.

Degas was never content to work in oil and pastel alone. He was also a great printmaker and sculptor, although most of his work in these fields became known only after his death. It would be natural that such a consummate draughtsman would be attracted to all the graphic techniques. He did his first etchings around 1857, at the time he was studying and copying in the Print Room of the Bibliothèque Nationale. In 1879 Degas, Pissarro, Mary Cassatt, and a few other friends joined together to publish a periodic journal featuring original prints. Unfortunately this magazine, to be called *Le jour et la nuit,* never appeared due to a lack of funds. However, Degas' interest in the project inspired him to produce his finest and most complex etchings, including *At the Louvre* (Figure 6). Although he had by then completely mastered the etching technique (in fact, he had his own press), he was constantly experimenting to achieve new effects. In the case of this print, of which there are at least twenty different states, Degas combined both hard-and soft-ground etching, aquatint, drypoint, and *crayon électrique* to attain the richly textured and varied surface.

Figure 12.
Bather (c. 1890)
charcoal on white paper
23½" x 18"
Durand-Ruel, Paris

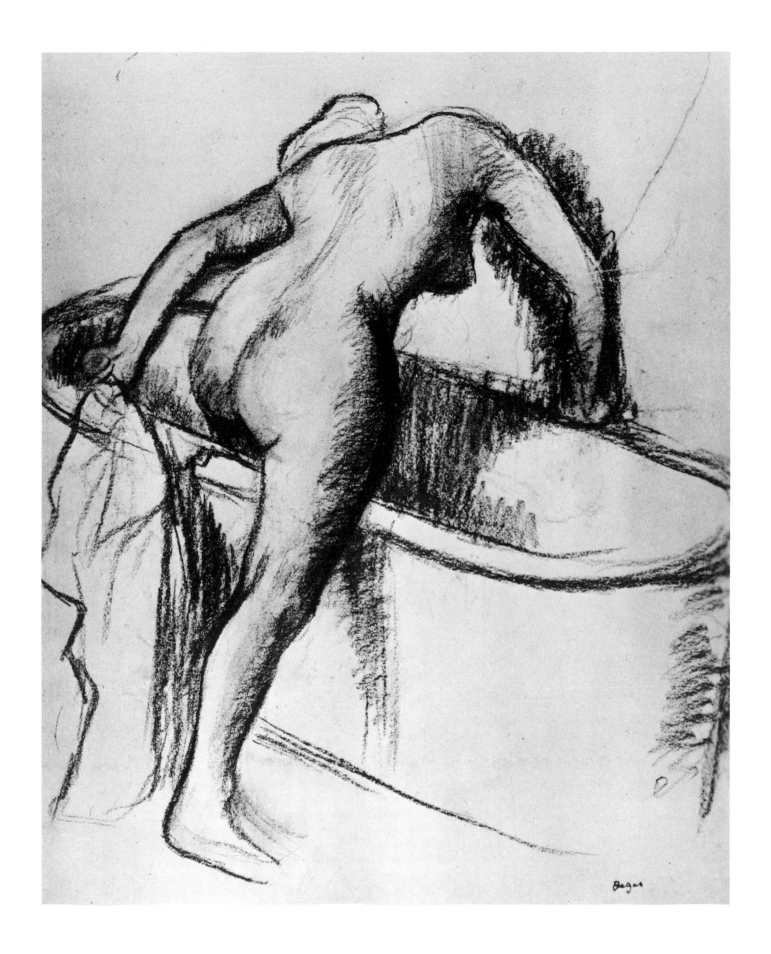

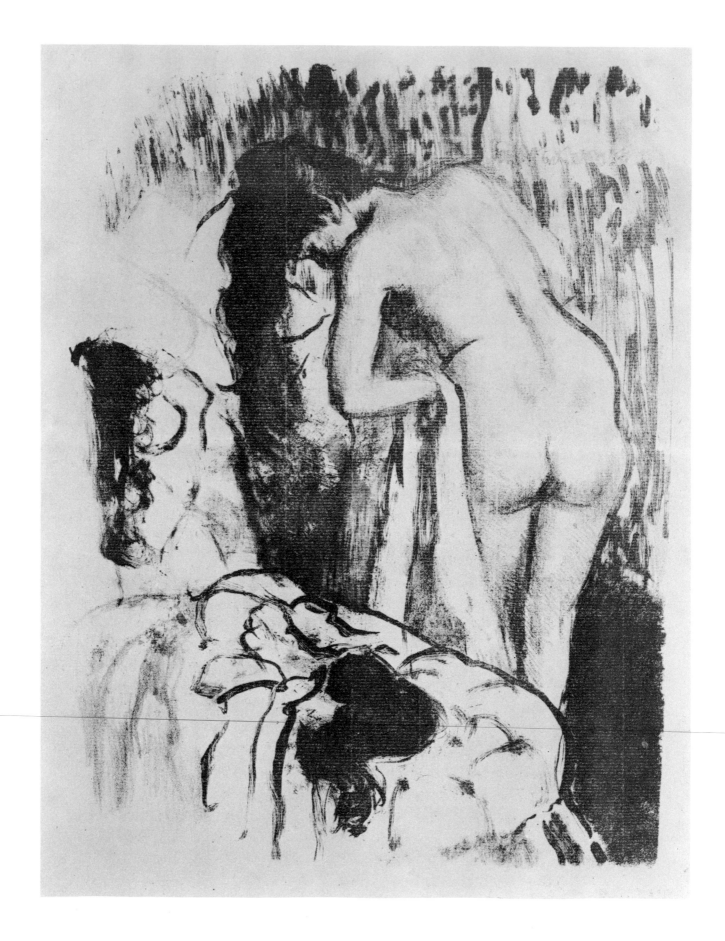

Besides etching, Degas also did a number of lithographs, of which *Standing Nude at Her Toilette* (Figure 13), one of a projected series of this subject, is the finest.

The great bulk of Degas' prints are monotypes, which number in the hundreds. He executed his first monotype around 1875, under the inspiration and direction of his friend Ludovic Lepic, and continued to work in the medium until the early nineties. A monotype is created by drawing with a brush or rag directly upon a blank metal plate in printer's ink. An alternative method, subtractive rather than additive, is to cover the plate completely with ink and then to wipe away some of it to create a composition. Then while the ink is still wet, an impression is taken from the plate. Only one or two impressions are thus possible, making a monotype almost as unique as a drawing.

Degas found this technique of great use in developing his compositions. If he was pleased with the result, he would use the monotype as the basis for a pastel, the chalk being applied right on top of the print (Slide 11). It has been estimated that one fourth of Degas' pastels have such a monotype base. In his monotypes he portrayed a wide range of subjects, including a series of landscapes and a never-published group of illustrations for Ludovic Halévy's *La Famille Cardinal,* a series of humorous short stories about two young ballerinas. *The Two Amateurs* (Figure 14), showing two men examining a work of art, is an excellent example of the spontaneous and fresh effects afforded by this technique. But only a few of his associates saw Degas' monotypes, which he never exhibited as independent works. In fact, it was only in this medium that Degas depicted prostitutes. His brothel scenes, a subject so closely associated with Toulouse-Lautrec, are viewed with Degas' usual detachment and objectivity, conveying a certain vulgar humor but no sensual enjoyment. A number of these brothel monotypes verge on the pornographic and, supposedly, the more licentious ones were destroyed by René de Gas before the estate sale following the artist's death.

As was the case with his prints, Degas' sculpture was almost completely unknown to his contemporaries. At the time of his death 150 sculptures were found in his studio in various states of disintegration. Only half that number were eventually saved and cast in bronze. Since Degas had no professional training in this field (he preferred the freedom of the amateur, unrestrained by technical knowledge), many more of his clay and wax models surely disappeared during his own lifetime. Yet what remains is a tremendous achievement. If all of his paintings were lost and only his sculpture remained, Degas would still be considered an important artist. For he is, after Rodin, the greatest French sculptor of his time.

Degas' sculptures are of three predictable subjects: horses, ballerinas, and women bathing. His first work, a statuette of a horse, was done as a model for a painting of 1868–70. This and similar works (Figure 15) were inspired by the animal sculptor Cuvelier, whose small bronze horses were popular at the Salon before the Franco-Prussian War. Many of Degas' sculptures relate to his pictures, either as studies for or models after a figure in a particular painting. Like his numerous drawings, sculpture was another method of understanding the complexities of his subject, in this case a three-dimensional exploration of form.

Figure 13.
Standing Nude at Her Toilette
(c. 1890)
lithograph
13¼″ x 9⅝″
National Gallery of Art
Washington, D. C.
Rosenwald Collection

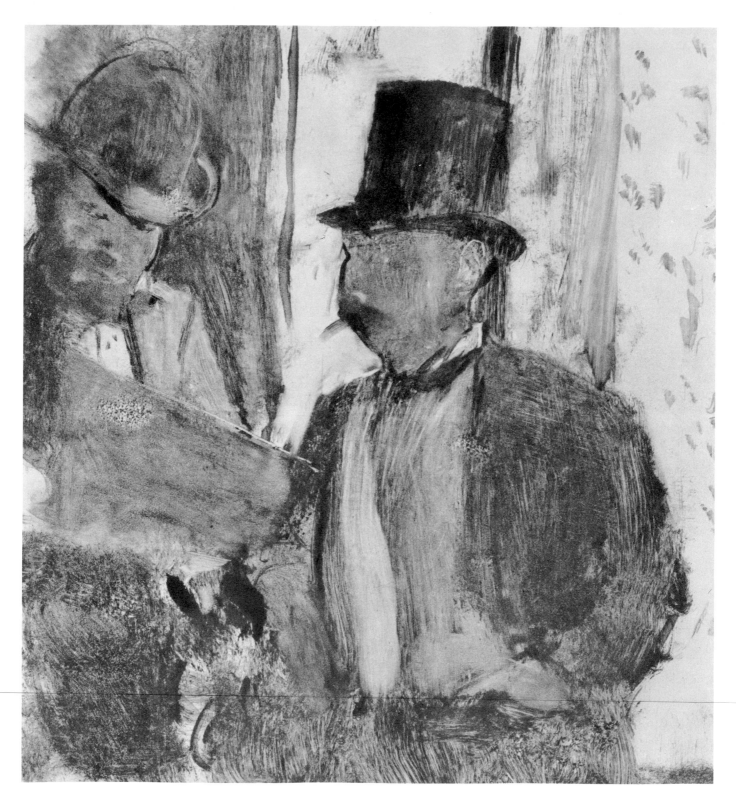

Figure 14.
The Two Amateurs (c. 1881)
monotype, 11 1/16″ x 10 11/16″
The Art Institute of Chicago
Clarence Buckingham Collection

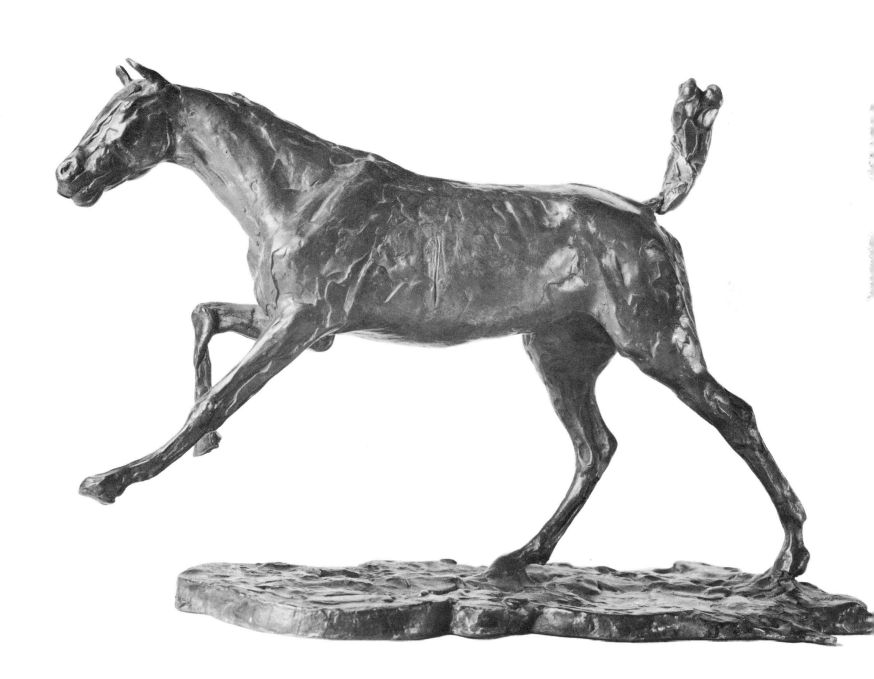

Figure 15.
Galloping Horse (1865-81)
bronze, 12¼″ x 18¼″
City Art Museum of St. Louis

Degas' later horse sculptures were influenced by the work of Eadweard Muybridge, the Philadelphian whose series of consecutive photographs first revealed the true locomotion of horses and humans. These sequential photographs, which appeared in a French scientific publication in 1878 and in the popular press during 1881 and 1882, were a revelation for a person like Degas with an inquiring and exacting mind. They showed for the first time the actual positions of an animal in motion and thereby destroyed, at least for Degas, the false artistic conventions for the depiction of such actions.

The most important, the most finished, and the largest of Degas' sculptures, that of a little fourteen-year-old dancer (Figure 16), was the only one exhibited during his lifetime, at the 1881 Impressionist exhibition. Visitors to the show were amazed by the realistic qualities of the original wax model of this work, heightened by the actual fabric of the tutu, and silk hair ribbon in which Degas dressed the figure. While distressed by the ugliness of the model, most critics showed a grudging admiration for what one called "the perfect truthfulness of gesture" embodied in the work. This quality was always one of Degas' ultimate goals.

In connection with this sculpture, it is appropriate to mention Degas' considerable talent as a writer. As his published letters show, he was a particularly fine correspondent, displaying none of the misanthropic qualities he is so often accused of later possessing. He read widely and had a number of literary friends, including the symbolist poet Stéphane Mallarmé. Mallarmé's poems were partly responsible for inspiring Degas to write some twenty sonnets on the same subjects he depicted in his paintings and sculpture. One of the most evocative of these (from *Degas Letters,* translated by Marguerite Kay) describes his sculpture, *The Little Dancer:*

Dance, winged child, in your stage built glade.
Dance be your life, dance be your charm.
In its sinuous line, let your slender arm
Gracefully balance your glide and your weight.

Taglioni awake! Come Arcady's princess!
Nymphs, graces, descend from your far off height;
With a smile at my choice, imbue with your light
This creature so new, so gallant of mien.

If Montmartre gave the forebears, the spirit so wise,
Roxelane the nose and China the eyes,
Harken, oh Ariel, give this young fay

The lightness, by day and by night, of your feet
And see, for my sake, in her golden palais,
She remembers her race, her descent from the street.

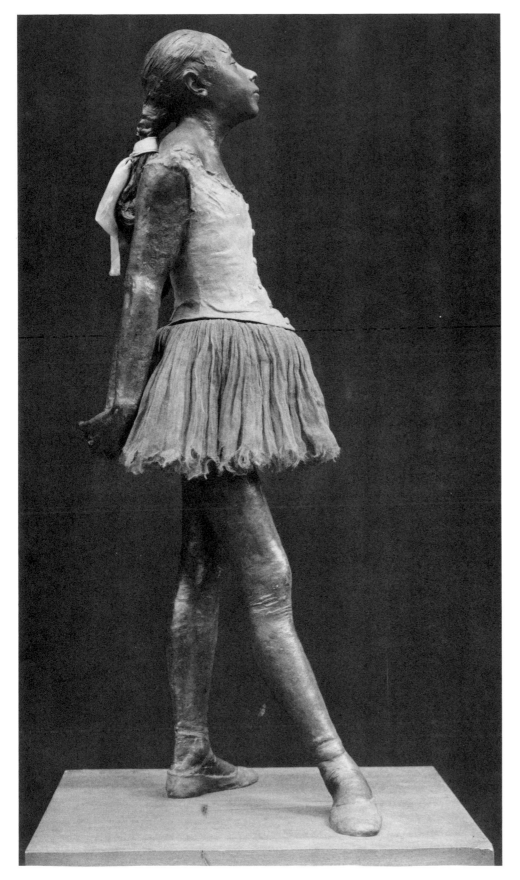

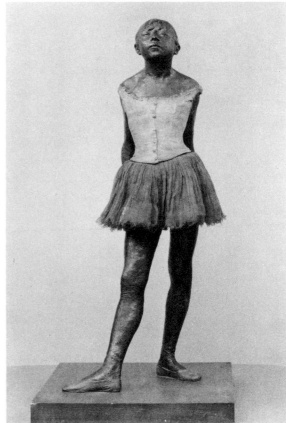

Figure 16.
Ballet dancer: statuette
bronze
tulle skirt and satin hair-ribbon
39″ high
The Metropolitan Museum of Art
Bequest of Mrs. H. O. Havemeyer, 1929
The H. O. Havemeyer Collection

Although a number of artists were inspired by his work, Degas had no pupils. The artist closest to him aesthetically was also emotionally the closest, the American, Mary Cassatt. Although we have no proof of an affair (Cassatt burned all of Degas' letters before she died), they were intimate friends for decades, enjoying a mutually beneficial working relationship. Both were from proper, upper-middle-class backgrounds; completely dedicated to their art, neither ever married. Degas first admired Cassatt's work in the Salon of 1874, remarking to a friend about one of her pictures: "This is genuine. Here is someone who sees as I do." They finally met in 1877 when he came to ask her to exhibit with the Impressionists. Cassatt later played a key role in introducing and promoting an appreciation of the Impressionists among American collectors, who bought their works long before the French. In a painting such as *Girl Arranging Her Hair* (Figure 17), which Degas owned, Cassatt displays the same detached, incisive observation and the same ability to capture the natural, essential gesture of a figure.

Another artist often associated with Degas is Jean-Louis Forain. While Forain depicted many of the same subjects, his work has a blandness and anecdotal character with none of the linear precision and strength of Degas. Although they never met, Henri de Toulouse-Lautrec always professed great admiration for Degas. While possessing a similar love of Paris, the younger artist preferred the debauched world of the Montmartre cafés and brothels, which he painted with satirical, often cynical insight. A certain Degas influence can also be seen in the early work of Édouard Vuillard and Pierre Bonnard, particularly in their intimate views of everyday life and their obvious Japanese inspiration. Later Bonnard frequently painted women bathing, with a richness of color similar to Degas' late works but with a sensuousness closer to Renoir.

Degas' last years were sad and bitter. By 1908, his blindness had progressed to the point where he could no longer work even in pastel. He did continue to model figures in wax for a few years more but finally even that became impossible. Blindness also prevented him from enjoying his art collection, rich in works by Ingres (whom he revered to the very end), Delacroix, and Corot, which he had assembled over the years. In 1912, the last of his childhood friends and his closest, Henri Rouart, died. In the same year Degas was forced to move from his apartment and studio of twenty years on the Rue Victor Massé to new quarters. During these final years he constantly walked the streets of Paris, in continual danger of being run over. Daniel Halévy later wrote of the artist: "What Parisian . . . has forgotten this singular figure, this old man with a white beard, covered by a heavy Macfarlan, indifferent to the rain, walking with rapid steps, bending slightly forwards and tapping the edge of the pavement with the end of his stick? Neither Homer with his vacant eyes, nor the haggard Lear on the edge of the cliff, presented a grandeur more tragic than the aged Degas wandering in our Paris streets." He finally died during the last days of the First World War on September 27, 1917. His funeral was attended by a few old friends and associates, including Mary Cassatt, herself nearly blind from cataracts. Degas had requested a simple funeral and had asked Forain to say at his grave merely: "He loved drawing very much."

Figure 17.
Mary Cassatt (1844-1926)
Girl Arranging Her Hair
(1886)
oil on canvas, 29½" x 24½"
National Gallery of Art,
Washington, D. C.
Chester Dale Collection

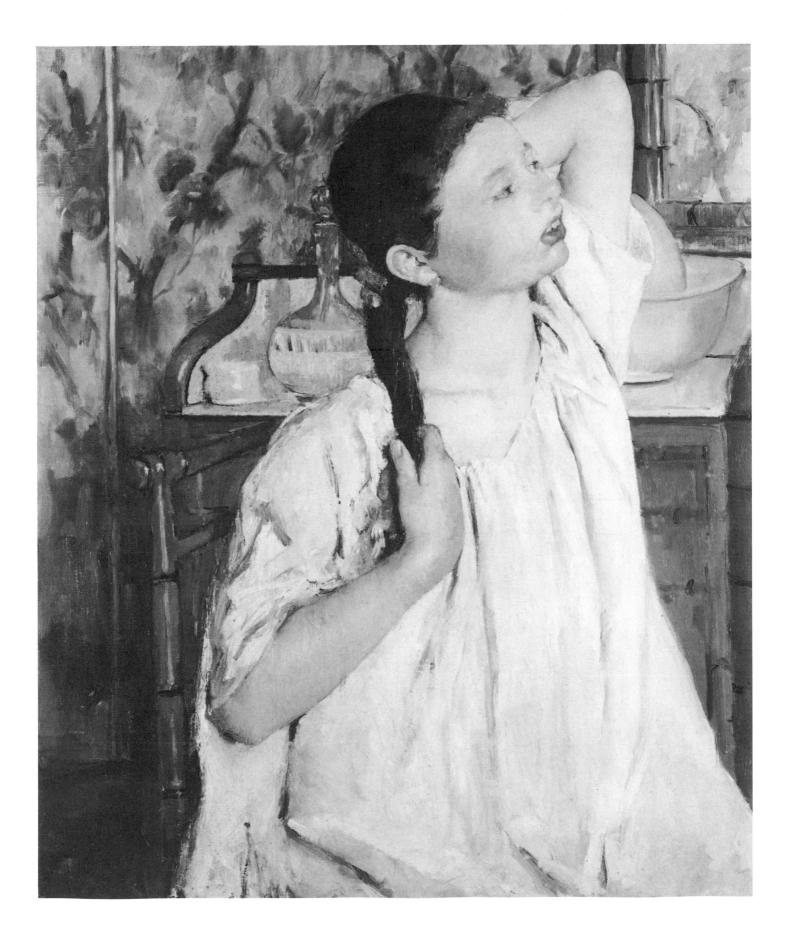

COMMENTARY ON THE SLIDES

1: THE BELLELLI FAMILY (1858–1860), oil on canvas, 78¾″ x 99½″
Louvre, Paris

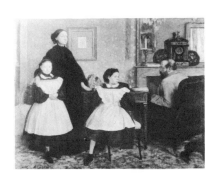

Degas arrived in Florence from Rome in early August 1858, staying with his aunt and uncle, Baron and Baroness Bellelli, until the following April. Bellelli had been exiled from Naples in 1849 because of his revolutionary activities in support of Italian unification. Only in 1860, with the creation of the kingdom of Italy, did he return to Naples, to become director of the city's postal and telegraph system and a Senator.

Soon after his arrival, Degas conceived the idea of a life-size group portrait of the Bellelli family in their own drawing room. During his visit he made innumerable studies of his relatives, which were used when the picture was painted during the following year in Paris. In part due to their enforced exile, the baron and baroness had long been estranged and this domestic tension was visually expressed by Degas in his painting. The artist's aunt, stern and aloof, psychologically dominates the picture (as she did the household), her arm protectively around her quiet, introverted daughter Giovanna. The other child, Giulia, active and animated, turns toward her father, pensive and withdrawn, who sits with his back to the viewer. The composition centers on the dark, pyramidal shape of the baroness, the clear contour of her body and head set off by the solid wall behind and emphasized by the framed picture. Reflecting an emotional separation, the baron, partially hidden by the chair, is visually separated from the others by the line created by the leg of the table and edges of the fireplace and mirror. The mirror itself, rather than creating a solid background, is ambiguous and indefinite in its reflections, while the objects on the mantle distract attention from the man's head. It is such psychological insight and characterizations which distinguish Degas' portraits from the superficial, academic ones of the period; in this case, making the picture more than merely a realistic depiction of a prosperous, bourgeois family in their comfortable surroundings.

The influence of Ingres, who did portrait drawings of similar family groups, and the Old Masters, particularly Bronzino, Holbein, and Van Dyck, is evident in the precise draughtsmanship and aristocratic pose of the baroness. But the realism of the setting and such elements as the decentralized composition and casual pose of the figures, the sensitive use of patterns, the development of abstract shapes (the white pinafores against the black dresses), and the use of a mirror to extend the pictorial space make this a totally original work, one of Degas' most important paintings.

35

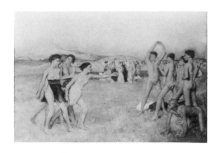

2: SPARTAN BOYS AND GIRLS EXERCISING (1860–1865), oil on canvas 42⅞" x 61", National Gallery, London

Between 1859 and 1865 Degas was seriously committed to becoming a history painter, as would be expected of a student of the École and a follower of Ingres. In his notebooks and in numerous drawings, he conceived a variety of such projects but completed only five major pictures. Of these, this is the most attractive and illustrates the varied, often conflicting influences then working to form Degas' mature style. Reflecting his thorough knowledge of classical literature, the subject—adolescent girls challenging Spartan boys to wrestle—was derived in part from Plutarch's *Life of Lycurgus*.

There are two versions of this subject. In both, the composition shows Degas' study of antique and Renaissance art. The bas-relief-like disposition of the foreground figures across the picture plane is contrasted to the spatial depth created by the separation of the youths by the open center, filled in by a background group of Spartan elders. The first, unfinished version, painted in 1860, is much more historicizing and academic. Certain figures are based on antique sculptures, the costumes are more detailed and accurate, the composition is closed in by foliage and a classical building in the background, and the figures are stiffly posed and gesture melodramatically. The version reproduced here, possibly completed as late as 1865, shows Degas' developing interest in realism, partly due to his recent friendship with Manet and Edmond Duranty. The landscape setting has been simplified, becoming open and expansive, the light warm coloring similar to his first racecourse pictures. More important is the appearance of the figures, now more naturally posed and modeled. No longer the classical ideal with Grecian profiles, these youths appear to be straight from the streets of Montmartre, contemporary types observed by the artist. A psychological interplay has developed between the two groups of adolescents, creating a sexual awareness and tension missing in the first version. Degas has combined the silhouettes and crossed limbs of the figures into two complex units, the one on the left compact and challenging, the other open and relaxed.

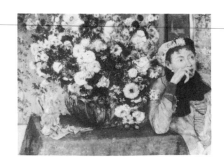

3: WOMAN WITH CHRYSANTHEMUMS (1865), oil on canvas 29" x 36½", Metropolitan Museum of Art, New York
The H. O. Havemeyer Collection, Bequest of Mrs. H. O. Havemeyer, 1929

There is only one pure still life by Degas known—a small, early painting of a bowl and a lizard, which, in its simplicity, is close to the work of Chardin. But Degas often incorporated bits of still life into his other paintings. On several occasions he depicted women next to an arrangement of flowers. In this picture, possibly of a Mme. Hertel of Rome, the still life dominates, almost overshadows the figure. The exuberance and fullness of the flowers recall similar bouquets painted by the realist Gustave Courbet, in particular a picture

of a woman picking flowers from a trellis, which Degas could very possibly have seen.

However, of much greater importance is the influence of Japanese prints; in fact, this is one of Degas' most audacious uses of the asymmetrical composition so typical of those woodcuts. And what flower is more symbolic of Japan, once known as the Land of Chrysanthemums? Degas placed the woman at the far right where she occupies less than a third of the composition, her body cut in half by the picture's edge. The mass of flowers dominates the center, while the glass pitcher and the lady's gloves, casually tossed on the table, help to balance the composition, acting as a visual foil to the figure. Japanese also is the shallowness of the space, accented by the flowered wallpaper at the left, which blends with the real chrysanthemums into a single pattern. The view of the flower garden through the open window at the right echoes this patterning. While there are some bright spots of color in the bouquet, yellow, red, and particularly white, the general coloring of the picture is subdued, with shades of brown predominating. This color subtlety is typical of Degas' work through the eighties.

For all the beauty of the flowers, this remains a strong portrait. As in *The Bellelli Family,* Degas has gone beyond the visual appearance to capture an impression of the inner mood and personality of the sitter. The woman stares off into space, her cheek resting on her hand, apparently lost in reflection or reverie, unaware of the encroaching bouquet.

4: LE VIOL (1868–1872), oil on canvas, 31⅞″ x 45⅝″
Collection of Henry P. McIlhenny, Philadelphia

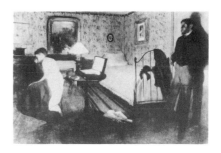

Degas, an articulate and literate person, was familiar with the work of the Naturalist writers, who in their novels and essays developed a literary style which realistically depicted contemporary life. During the 1860s, at the Café Guerbois, Degas met a number of these men, including Zola, Edmond Duranty, J. K. Huysmans, and Edmond de Goncourt. Duranty became a close friend of the painter and urged him to turn his attention to a visual depiction of contemporary urban life, rendered in an impartial, objective style.

At this time Degas was painting a number of narrative themes derived from classical sources (*Spartan Boys and Girls Exercising*) and the opera (*La Source*). It would seem logical that he would also turn to the Naturalist writers for inspiration. This appears to be the case with this painting known as *Le Viol (The Rape)* and, less dramatically, as *Intérieur.* It supposedly represents a scene from Emile Zola's *Madeleine Férat,* first published in 1868. The novel concerns a woman who cannot forget a love affair before her marriage, with her husband's best friend. In fact, no rape occurs in the story. Rather, the novel centers on the confrontation between the wife and husband in a hotel room, which coincidentally is the same one occupied in the past by Madeleine and her lover. In the climactic scene, filled with guilt and despair, she confesses the affair to her husband and then rejects him. Since the painting does not follow exactly the detailed description of this

episode in the book, it may instead represent the preceding scene when, in her husband's absence, Madeleine is visited by her ex-lover, who, even more coincidentally, is staying at the same hotel. Degas probably telescoped elements from both scenes into his painting, preferring to capture the mood of frustrated emotion rather than merely illustrating Zola's text.

This feeling of frustration and tension is brilliantly conveyed by Degas in his manipulation of the elements of the composition. The room appears to be small, with the objects filling the space, creating a feeling of physical confinement. The deep central perspective achieved by the repeated diagonals of the floor boards, the rug, and the edges of the bed, draw the viewer into the picture. A mysterious, almost ominous, effect is achieved by the shadowed lighting from the single lamp. As in a Naturalist novel, great attention has been given to a description of the setting, which is vividly realistic in its details: the faded wallpaper, the open traveling case, the woman's discarded corset on the floor. Of particular importance is the narrow, virginal bed, symbolic of Madeleine's domestic tragedy. Degas has not made this drama obvious or easily comprehensible. Nothing is contrived or posed. Rather he has subtly captured the psychological struggle between the two characters, the quiet despair of the woman, the suppressed emotion of the man.

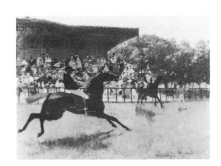

5: THE FALSE START (1869–1872), oil on canvas, 12⅝" x 15¾"
Collection of Mr. and Mrs. John Hay Whitney, New York

The racecourse pictures Degas began to paint after his 1861 visit to the horse country of Normandy presented him with an opportunity of combining modern life and landscape. Strangely, he is the only member of the Impressionist circle, excepting Manet, to depict this subject, with the changing light and shadow of its outdoor setting. For all of Degas' attraction to the subject, he was not a horseman himself. He was not interested in depicting the social or technical aspects of the sport. Nor are his pictures historical documents, for they never portray a specific horse, jockey, identifiable stable colors, or a particular race. He was solely interested in the movement and form of horse and rider. For this reason he almost always preferred to paint the moment before a race, when the excited horses are tense with pent-up energy. In contrast, Manet was interested in the excitement of the race itself, even painting a head-on view of the horses racing down the track.

This is one of Degas' simplest race compositions, featuring just two horses attempting to get in line for the start of a race. Unlike most of his race paintings, this can be identified as the Longchamp track near Paris. The composition is dominated by the foreground horse, whose beautifully drawn silhouette stands out against the green turf. By placing the horse to the left of center, Degas emphasizes its movement forward into the space left open at the right. The grandstand is filled with featureless spectators, rendered with broad, sum-

mary brush strokes. The shapes of the women's open parasols create a decorative pattern along the track rail. While the picture is drenched in sunlight, conveyed in part by the shadows cast by the horses and trees, the general coloring is restrained and cool.

6: THE COTTON OFFICE, NEW ORLEANS (1873), oil on canvas
29⅛″ x 36⅛″, Municipal Museum, Pau, France

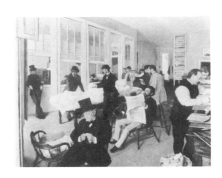

During his stay in New Orleans, Degas wrote his friend Jacques Tissot: "One does nothing here, it lies in the climate, nothing but cotton, one lives for cotton, and from cotton." This fact of Southern life was particularly true of his mother's Creole family which was engaged in the cotton export trade. In this painting, the most important to result from his American sojourn, Degas depicted the interior of the Musson business office filled with family and employees. Seated in the foreground is his uncle Michel Musson, critically examining the firm's product, while diagonally behind him, reading a newspaper, is René de Gas, and at the far left, leaning languidly against the partition, Achille de Gas.

Degas realistically captured what could have been any daily cotton-office scene, each person preoccupied with his own activity, oblivious to being observed. He has created a deep perspective which pulls the viewer into the scene diagonally to the right. This spatial recession is achieved by the slanting floor, the overlapping of the figures, and the exaggerated diminishing of the size of the figures as they move away from the viewer. The rhythm of the repeated rectangles of the partition windows along the left wall, with their emphatic vertical lines, adds to this effect. Here color is minimized, with contrasting black and white and shades of tan predominating.

Degas was pleased with this picture and had hopes that it might make his reputation among English collectors as a painter of contemporary, urban subjects. He urged Tissot, then living in England, to help him place it with a London dealer who could sell it to a Manchester cloth manufacturer. "For," he wrote, "if a spinner ever wished to find his painter, he really ought to hit on me." While this wish was not realized, the work did meet with some success, for in 1878 it was the first of Degas' paintings to be acquired by a museum.

7: THE REHEARSAL (c. 1873), oil on canvas, 31⅞″ x 25⅝″
Courtesy of the Dumbarton Oaks Collection, Washington, D.C.

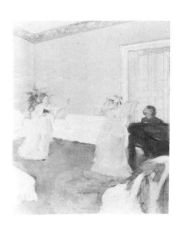

Degas shared with both his father and Manet a deep love of music. He had many talented musicians as friends and regularly attended domestic musicales and concerts at the Opera and the popular cafés. This passion resulted in a great variety of paintings with musical entertainment as their theme.

In this picture two women are rehearsing in a drawing room. This work gives the impression of being a snapshot due to the suspended movement and gestures of the figures, the cropping of objects by the frame, and the asymmetrical composition. The unfinished quality even duplicates the blurred effect of an instantaneous photograph, particularly in the head of the pianist caught turning to the left, his features unrecognizable.

While the color is restrained, Degas has created a marvelously open, light, and airy atmosphere, so different from the dark, confined space in *Le Viol* (Slide 4). This scene must be taking place during the summer since the furniture is covered with white slip-covers and the women are wearing the light, filmy dresses of that season. The chalk-white shapes of the sofas, clothing, and the door, against the salmon-pink walls and brown floor, with the single bright red accent in the foreground, creates this striking effect.

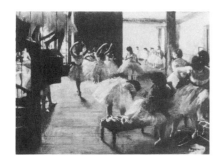

8: THE BALLET SCHOOL (1873–1874), oil on canvas, 18¾″ x 24½″
The Corcoran Gallery of Art, Washington, D.C., W. A. Clark Collection

In the public mind Degas is associated principally with the ballet, which he lovingly depicted for over thirty years. It was after his return from New Orleans in early 1873 that he began to pursue this subject in earnest—on the stage, at rehearsals, and in the practice room. His first ballet pictures were small in scale but showed large numbers of figures—in this particular painting there are nearly two dozen. Filled with individual dancers in the greatest variety of poses, these early works became visual pattern-books to which he would refer for motifs for later paintings.

During the seventies, fascinated with life backstage, Degas preferred to set his scenes in the practice rooms and rehearsal halls of the Opera. Here the girls are preparing for a class: descending the stairs from the dressing rooms, adjusting their costumes and relaxing, and finally moving into the practice room in the far background. Degas has dressed them in the correct practice costume of the period: longish tutus and flesh tights, adding only brightly colored sashes and neck ribbons for decoration. Then, as now, classes lasted about an hour and a half, beginning with exercises at the bar, followed by a prescribed routine of positions and movements. During these exhausting and repetitious sessions, Degas was able to examine thoroughly the movements and gestures of the dancers. The constant physical conditioning and practice required of a ballerina presented a perfect opportunity for an analytical study of the human body. Degas brought to the artificial and glamorous world of the theater a new visual honesty, preferring the unconventional, strained, even awkward pose of a figure to the idealized and clichéd.

In this picture, bright daylight filters through the windows at the left, silhouetting the spiral staircase and setting the dancers off against the floor and dark wall. The sense of a contained, limited space is broken and extended by the windows and the distant room beyond.

9: THE DANCE CLASS OF MONSIEUR PERROT (1874), oil on canvas
34″ x 30″, Louvre, Paris

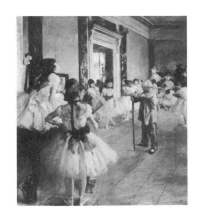

Just as his racecourse pictures record a male preoccupation, so Degas' depictions of the ballet are almost exclusively feminine. In fact, he never painted a male student or adult dancer. Only occasionally would a man appear as *maître de ballet* instructing a class. Here the teacher is Jules Perrot, a choreographer and the former partner of Marie Taglioni, the greatest ballerina of the Romantic period of the 1830s and 1840s. The artist has sympa-thetically shown the old man leaning on his tall cane, waiting for a dancer to perform. Degas often repeated the same composition with subtle differences. In another version of this scene a dancer is actually caught in the middle of a movement, upraised on one toe.

Degas has dramatically organized the perspective of this large room, similar in manner to *The Cotton Office, New Orleans* (Slide 6). The two walls—the left placed on a sharp diagonal—come together to form a wedge-shaped space. As in Japanese prints, the floor tilts upward as it recedes, emphasized by the diagonal lines of the floor boards. Like the viewer, the foreground figures look into the picture at Perrot and his pupils, who, filling the middle and background, are noticeably smaller in scale. This diminution in size and the sensitive overlapping of forms increase the sense of movement toward the back of the crowded room.

The scene is evenly lit and the color is restrained and cool, enlivened by the bright hues of the girl's sashes. A mirror, often used by Degas to add another dimension to a room, breaks the solid surface of the left wall, reflecting the windows on the opposite side. The details of the foreground particularly attract our attention. Degas enjoyed showing the dancers relaxing and the casual gesture of the seated girl twisting her arm around to scratch her back is a wonderfully unorthodox example of his search for the unique pose. The small dog peeking at the viewer adds a humorous touch, as does the incongruous watering can by the piano, used to sprinkle down the dust of the dance floor.

10: ABSINTHE (1876), oil on canvas, 36¼″ x 26¾″, Louvre, Paris

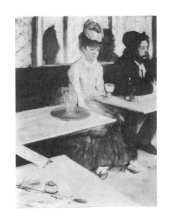

Around 1876, Degas, Manet, and their friends, forsaking the Café Guerbois, began to meet regularly at the Café de la Nouvelle-Athènes on the Place Pigalle. This painting, titled after the glass of pale green liqueur, represents two of Degas' friends seated at one of the marble-topped tables on the terrace of the café. The man, Marcellin Desboutin, was a writer, painter, and printmaker of minor talent, who consciously practiced a picturesque, Bohemian life style. The woman, Ellen Andrée, was a pantomime actress who posed on several occasions for the artist.

Degas transformed this double portrait into a penetrating psychological study of the more dissolute aspects of the café world of Paris. The dejection and sadness of the actress,

whom we know from a Renoir painting actually to be quite pretty, is conveyed by her slumped shoulders, disheveled costume, and the glazed, vacant expression caused by the narcotic effect of the absinthe. No communication exists between the two figures. Both are lost in a negative escapism, always the dark side of Bohemianism. Degas has thrust the viewer directly into the scene, as if he were sitting behind the foreground table. Again the influence of Japanese prints is strong, particularly in the marvelous manipulation of the flat surfaces of the tables to create the diagonal recession which leads the eye in a zigzag pattern to the couple. Somber colors contribute to the mood of depression and weariness.

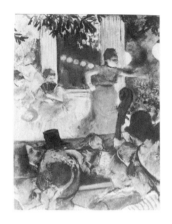

11: CAFÉ-CONCERT: LES AMBASSADEURS (c. 1876–1877), pastel on monotype on paper, 14½″ x 10⅝″, Museum of Lyons, Lyons, France

The café-concerts of Paris, given outdoors in the evenings in the park along the Champs Elysées, attracted Degas and his friends, including Manet and Renoir. Degas was particularly interested in the unusual lighting effects created by the dazzling footlights of the stage and the gas lamps scattered through the audience. He vividly captured the liveliness of these popular performances, another aspect of his visual record of the city's entertainment life. Always interested in exaggerated gestures, Degas would depict the singers in the midst of a number, dramatically throwing back their heads, their mouths open and arms outstretched. Sometimes, by such overstatement, he satirized these overripe soubrettes, in their brightly colored gowns and black velvet neck ribbons. But the vulgar quality of the café-concerts is found to a far greater extent in the later works of Toulouse-Lautrec.

In this picture, Degas has divided the composition into three horizontal sections: the foreground filled with the heads of the audience, of which the viewer is made to feel a part, the orchestra, and the stage. Our attention, like the audience's, is focused on the gesturing singer, the curving top of the bass viol serving as a visual link between the audience and this performer. Degas used a monotype as the base for this small pastel, the dark ink making an ideal ground for the creation of a night scene.

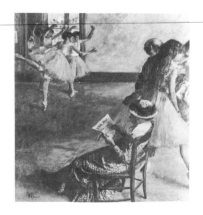

12: THE BALLET CLASS (c. 1878), oil on canvas, 32″ x 29½″
Philadelphia Museum of Art, Wilstach Collection, Photograph by Alfred J. Wyatt

During the late seventies, Degas' dance compositions tended to become simpler, with fewer figures. Here again he depicts young pupils practicing under the critical eye of a *maître de ballet*. Usually from poor families, hoping through the ballet to gain a higher status, these young girls, called "rats," were special favorites of the painter. He shows three of them engaged in a *pas de trois,* the front girl executing a rather poor *arabesque*. Degas possessed a specialist's knowledge of the dance which he used to depict with absolute accuracy the

conventions and movements of classical ballet. The fact that in this picture he showed a dancer in a less than perfect position indicates both his analytical objectivity and his humorous regard for these young students as they struggled laboriously to perfect their art.

This is, in fact, a very amusing picture. The viewer looks down on the funny figure of a slouching chaperon seated in the foreground, reading. Her bright blue, patterned dress and feathered hat are in sharp contrast to the diaphanous costumes of the dancers. The round form of the woman's head, with its piquant profile, is echoed by the balding head of the instructor.

The composition has been divided into two distinct parts by a diagonal line of a floor board, which begins at the woman's outstretched feet, coincides with the top edge of her newspaper, and extends back to the wall. To the right of this line, Degas has concentrated four large figures, grouped closely together. This crowded effect and the cutting off of the dancer at the right by the frame creates a feeling of space continuing beyond the edge. In the spacious left half of the composition, the three young pupils are placed in the upper background, in front of a mirror which reflects the window on the opposite wall, with its beautiful view of Paris rooftops.

13: AFTER A COSTUME BALL (MME. DIETZ-MONNIN)
(1879), pastel, tempera, and oil on canvas, 33¾" x 29⅝"
Art Institute of Chicago, The Joseph Winterbotham Collection

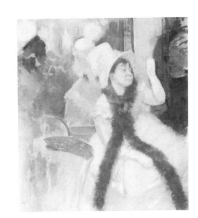

Although over one-fifth of Degas' work can be called portraiture, there is little evidence that he ever accepted a formal commission. The possible exception may be this portrait of Mme. Charles Frédéric Dietz-Monnin, a prominent figure in Parisian society. Degas' strict adherence to visual reality and his inability to flatter the sitter would have prevented him from becoming a fashionable portraitist. At one point in his work on the picture, the lady proposed to send Degas only her costume rather than coming in person for the sitting. Enraged, he wrote her: "Let us leave the portrait alone, I beg of you. I was so surprised by your letter suggesting that I reduce it to a boa and a hat that I shall not answer you. . . . Must I tell you that I regret having started something in my own manner only to find myself transforming it completely into yours? . . . I cannot go into this more fully without showing you only too clearly that I am very much hurt."

While the portrait was never finished and always remained in the artist's possession, Degas considered it important enough to send to the 1879 Impressionist Exhibition. It marvelously evokes an end-of-the-party mood, with the soft muted colors, the blurred reflections in the mirror, and the mixed expression of pleasure and exhaustion on the woman's face, her arm upraised waving farewell, with the boa twisted casually around her neck, like a furred snake.

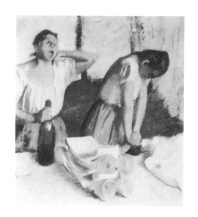

14: THE LAUNDRESSES (1882), oil on canvas, 32¼" x 29½"
Collection of Mr. and Mrs. Norton Simon, Los Angeles

Degas' interest in contemporary urban life, paralleling a similar interest on the part of the Naturalist writers, is particularly apparent in his paintings of laundresses, which first appeared in 1869. It has been suggested that he was initially attracted to this subject by the picturesque passages describing a laundry in Edmond de Goncourt's novel *Manette Salomon* of 1867. While these paintings are Degas' only pictorial excursion into the world of the lower class, there is no attempt to comment on the humiliating working conditions of these women. Rather, Degas was interested in objectively recording the exaggerated and strained poses of the laundresses as they struggled through long hours of exhausting and boring labor. It is the monotonous and repetitious quality of their work, similar to the practicing routines of the ballerinas, which fascinated the artist.

In this painting, Degas has contrasted the actions of two laundresses, one working, the other relaxing. The figure on the right is a marvelous example of Degas' ability to simplify action into an essential gesture. Here the long curve of the woman's back, neck, and head emphasizes the rigidity of her straight arms as the weight of her body presses down onto the heavy iron. The other figure who, grasping the water bottle used to sprinkle the clothes, pauses to stretch and yawn, makes a perfect foil for her laboring companion. The whiteness of the entire composition—the laundry hanging in the background, the women's blouses, the table—beautifully conveys the light-filled, airy atmosphere of the work room. The viewer's attention centers finally on the nearly abstract stack of freshly ironed and starched shirts in the foreground, whose stiffness contrasts to the limp, exhausted condition of the women.

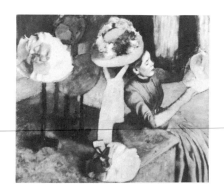

15: THE MILLINERY SHOP (c. 1885), oil on canvas, 39⅛" x 43⅜"
Art Institute of Chicago, Mr. and Mrs. Lewis L. Coburn Memorial Collection

Another aspect of contemporary life to attract Degas' attention during the 1880s was the shops of the dressmakers and milliners of Paris. He had a great interest in female fashion which he shared with Mary Cassatt, and with her or other lady friends would regularly visit the modish establishments of the city to see the latest creations. When asked by one such companion what he found so fascinating about these shops, the painter replied, "The red hands of the little girl who holds the pins." Certainly the gestures of the milliners as they held out their products for admiration or adjusted a hat on a customer's head touched Degas' imagination.

In this example, one of a dozen such paintings, a saleswoman is seated arranging the decorations on a hat held in her outstretched hand. Seen from above, a favorite perspective of Degas, she is partially hidden and dominated by the many hats which fill the left half

of the composition. This picture is, in fact, a still life of hats. The round emphatic shapes of these fancy headdresses are contrasted to the repeated verticals of their stands, the long green ribbon in the center, and the windows behind. The varied colors and rich materials of these hats also contrast with the woman's plain-Jane profile and simple dress.

16: THE TUB (1886), pastel on paper, 27½″ x 27½″
Hill-Stead Museum, Farmington, Connecticut

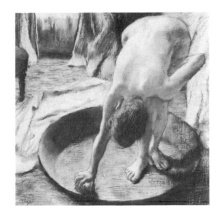

After 1880, Degas' long study of the human figure culminated in an extraordinary series of female nudes. The artist's expressed aim was to show these women "deprived of their airs and affectations, reduced to the level of animals cleaning themselves." This clinical objectivity and detachment separated these pictures from those of his contemporaries, from the lascivious, academic Venuses of Bouguereau to the sensuous, warm women of Renoir. There is a chaste and puritan quality about Degas' nudes which denies any temptations of the flesh. He does not idealize, beautify, or sentimentalize his subjects. As always he was interested in the movement of the body, the action and tensions of the muscles engaged in spontaneous and natural activity.

Degas showed his models bathing in both the high-sided tub, familiar today but rarer then, and the round, shallow, tin basin, seen in this pastel. The latter type forced the bather into awkward contortions as she bent down to reach the water and twisted about to wash her body. These were exactly the unconventional and unique positions which Degas sought, discovering in them a new, uncompromising truth about the human body which his Victorian contemporaries found ugly and degrading.

Here, as in most of his nudes, Degas has hidden the face of the woman, thereby denying her individuality. The tense outstretched arm and line of the body divide the composition diagonally, concentrating our attention on the hand grasping the sponge. The emphatic shape of the round basin, echoed by the curves of the head and hips, dominates the unusual square format. The scene is observed from above, the viewer hovering over the bent woman. Degas has surrounded her with various soft materials—the bed sheets at the right, the towel on the floor, the gauze curtains and blue drapes—which contrast to the solidity of the body and basin. The whole scene is bathed in a diffuse light which subtly models the figure, revealing the contours and protrusions of the back. The pastel here is laid down with precision and evenness, usually in close, parallel strokes.

17: BEFORE THE START (c. 1893), pastel on paper, 27½″ x 24½″
Collection of Mr. and Mrs. Sidney F. Brody, Los Angeles

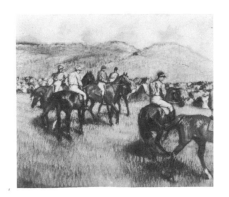

In the 1890s, in part due to his failing eyesight, Degas' work began to change. By then he had given up oil painting and worked almost exclusively in pastel, the chalk applied more

broadly than before in large, broken strokes. While he continued to depict the same subjects, his colors intensified, detail was eliminated, and forms became generalized. In his racecourse pictures, Degas no longer sketched the thoroughbreds at the track, using instead his earlier studies, his horse sculptures, and the consecutive photographs of the animals by Eadweard Muybridge as his models.

A comparison between this pastel and *The False Start* (Slide 5) illustrates these changes. Both depict the horses pacing about before a race. But the landscape in the later work has been completely generalized, lacking any indication of a specific place, merely anonymous, grass-covered hills. Spectators are usually eliminated in these late pictures. Degas has retained his extraordinary sense of composition, here contrasting the background group with the pair of foreground animals, with only the rear half of the closest horse visible as it moves out of the pictorial space, cut by the framing edge. The arrangement of the horses' legs in the background combines to form a complex decorative pattern. Color is no longer restrained and subtle but is bright and vivid, in part due to Degas' method of superimposing layers of pastel, which gives a richness and depth to the surface.

18: WOMAN AT HER TOILETTE (c. 1903)
pastel on paper, 29⁷⁄₁₆″ x 28½″
Art Institute of Chicago, Mr. and Mrs. Martin A. Ryerson Collection

Degas continued to explore the theme of women bathing for over two decades. Depictions of a model bent forward, toweling the back of her neck occur throughout this twenty-year period. In a late example such as this, the nude figure has achieved a massive and heroic quality. The composition is concentrated on a fragment of the body, the portion above the waist. Due to his weak eyesight, Degas could no longer depict the subtle details of anatomy. Rather the emphasis is on a bold, almost schematic rendering of the essential gesture of the body, the contours of the arms and the curve of the spine strengthened by black chalk.

The pastel is no longer evenly applied but is criss-crossed, scribbled, and slashed onto the paper. The background and accessories have lost their ability to define the space, which is flattened and ambiguous. Abandoning the discipline of line, Degas at last allowed himself the freedom to use the most extravagant and intense colors.. This vivid color, no longer corresponding to natural appearances, endowed Degas' late works with an expressionistic power and exuberance which, in anticipating the Fauves, makes him an artist of the twentieth century.

19: MME. ALEXIS ROUART AND HER TWO CHILDREN (c. 1905)
pastel on paper, 63" x 55½", Musée du Petit Palais, Paris

"I am meditating on the state of celibacy and a good three-quarters of what I tell myself is sad," Degas complained to his old school friend, Henri Rouart. By 1900, many of his oldest companions had died, while other friends had broken with the painter because of his anti-Semitic stand on the controversial Dreyfus affair. During the last two decades of his life, confined increasingly to a lonely seclusion by approaching blindness, Degas showed the deepest affection for Rouart and his family, once writing Henri: "For you there is no commission, no work, no anything that I would not leave for the pleasure of seeing you, do you hear, my old friend." Degas was practically a member of the Rouart household, dining with them every Friday evening, becoming a willing participant in their domestic affairs.

Over the years Degas painted portraits of several members of this large family. His last work in the field of portraiture was a series of pastels of Mme. Alexis Rouart, wife of Henri's oldest son, and her two children, of which this is the most finished. Here Degas worked on a larger scale than usual so that he could more easily see the forms he was creating. As was the case with his late works, there are various studies for and several versions of this subject, indicating his struggle to achieve success. He would start to work on a picture, but becoming dissatisfied with the results would abandon it and begin another version and sometimes yet another. A portrait presented an even greater challenge than a ballet or race picture since he was required to characterize a particular individual.

In his earlier portraits, such as *The Bellelli Family,* Degas visualized the psychological nature of his sitters. He has attempted such an analysis here, grouping the mother and son at the left and turning the daughter forcefully in the opposite direction to suggest a possible emotional conflict. But the meaning is imprecise due to the inarticulated bodies, the lack of narrative detail, and the insubstantial setting. Degas was no longer interested in or able to capture the individuality of his subjects. The faces are distorted, even ugly, and there is a general restlessness and indecision in the composition.

20: BALLET SCENE (c. 1906–1908), pastel on cardboard, 30¼" x 43¾"
National Gallery of Art, Washington, D.C., Chester Dale Collection

During the 1880s Degas delighted in showing the ballerinas in the midst of a performance. In his last depictions of this, his favorite subject, the dancers are usually massed together in the wings behind the brightly colored flats, preparing to make their entrance or exhausted from a performance. The figures are compactly grouped, their bodies overlapping to create

a complex and dramatic pattern of limbs. Many of his compositions from this and earlier periods have an extended, frieze-like horizontal format, reflecting his desire to paint murals. In this pastel, dating from Degas' last productive years before blindness overcame him, six dancers are strung across the paper. The progressive rhythm of their arrangement, each dancer in a variation of the pose of the next, creates a cinematic quality, similar to the series of consecutive, time-lapse photographs of Muybridge.

As with all Degas' late pastels, detail has been eliminated. The bold, essential forms of the dancers dominate the composition, achieving the simplification and concentration found in his sculpture. The entire picture is drenched with an exotic and intense color, crushed down onto the paper layer upon layer, creating rich, jewel-like effects. It is an extraordinary achievement that Degas could triumph over his terrible affliction to create such a powerful and moving work.

SELECTED BIBLIOGRAPHY

Jean Sutherland Boggs, *Portraits by Degas*, Berkeley and Los Angeles: University of California Press, 1962.

Jean Sutherland Boggs, *Drawings by Degas*, St. Louis: City Art Museum, 1967.

Lillian Browse, *Degas Dancers*, London: Faber & Faber, 1947.

James B. Byrnes, ed., *Edgar Degas, His Family and Friends in New Orleans*, New Orleans: Isaac Delgado Museum of Art, 1965.

Pierre Cabanne, *Edgar Degas*, Paris: Tisné, 1958.

Edgar Degas (Marcel Guerin, ed.), *Letters*, Oxford: Bruno Cassirer, 1948.

Eugenia Parry Janis, *Degas Monotypes*, Cambridge, Mass.: Fogg Art Museum, 1968.

Paul Lafond, *Degas*, 2 vols., Paris: H. Floury, 1918-19.

Paul-André Lemoisne, *Degas et son oeuvre*, Paris: Brame et de Hauke, 4 vols., 1947-49.

John Rewald, *Degas Sculpture*, New York: Harry N. Abrams, Inc., 1956.

John Rewald, *The History of Impressionism*, rev. ed., New York: The Museum of Modern Art, 1961.

Denis Rouart, *Degas à la récherche de sa technique*, Paris: Floury, 1945.